This Coloring Book

BELONGS TO

Copyright © 2019 By TS Color Press

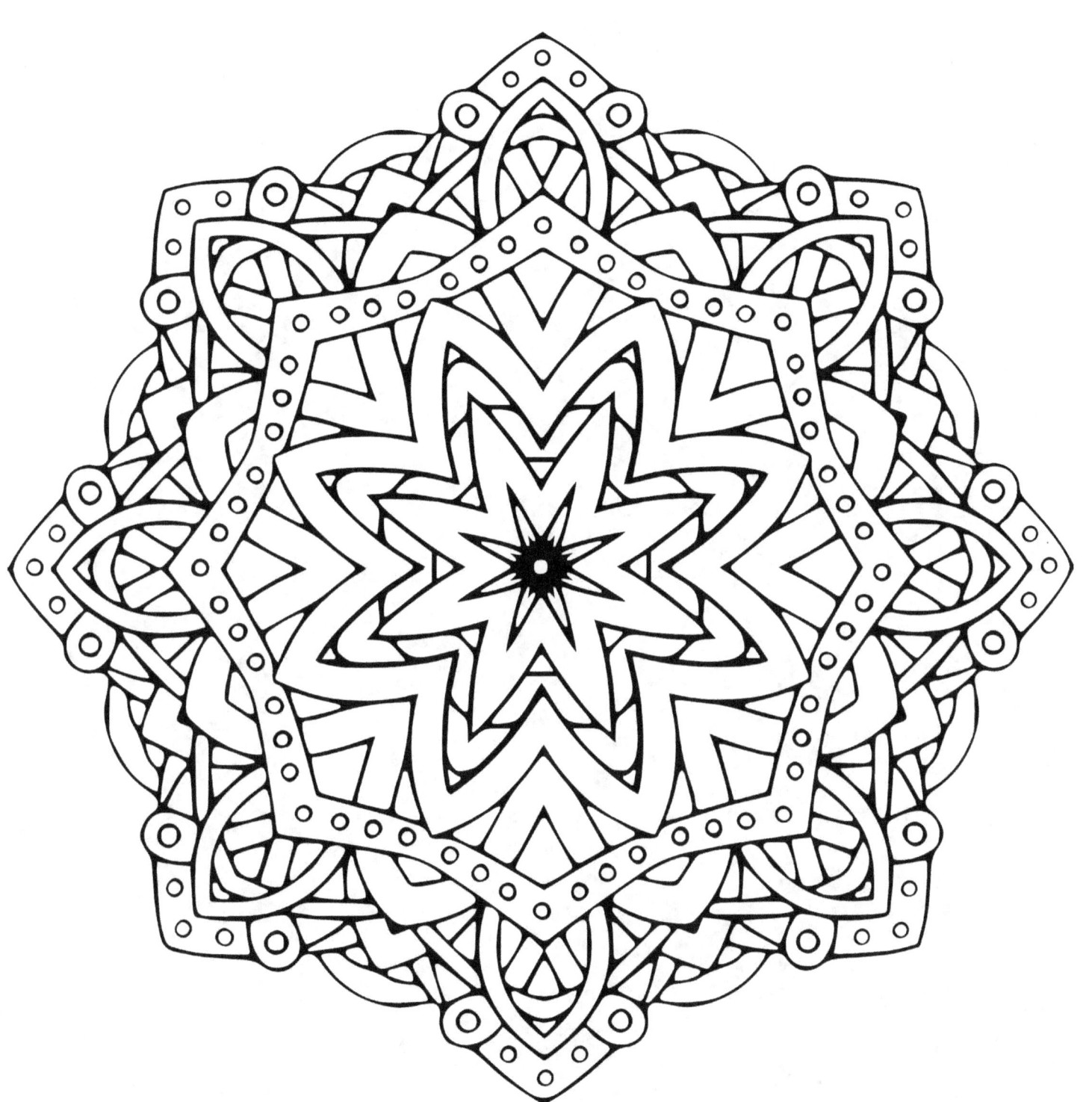

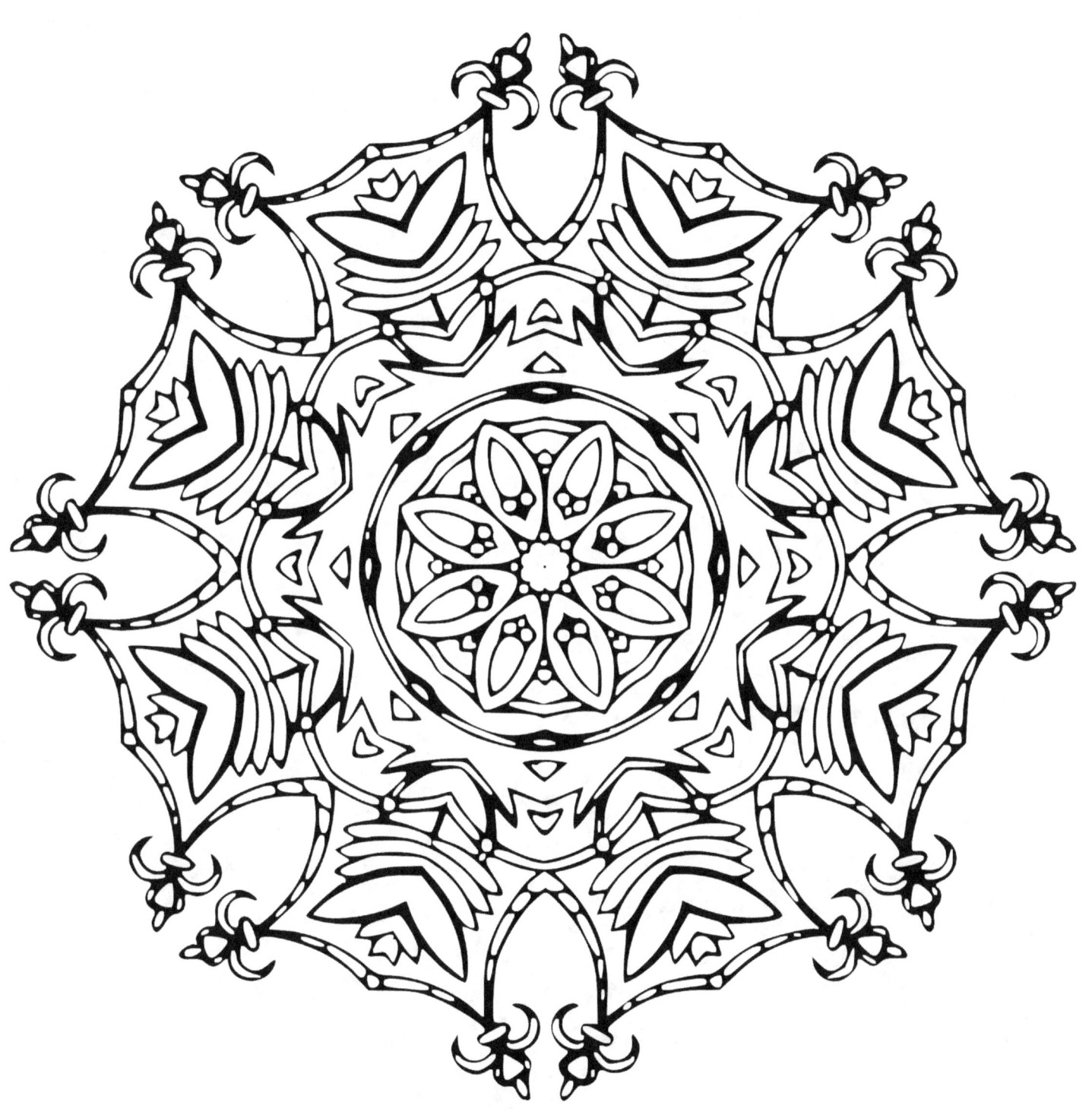

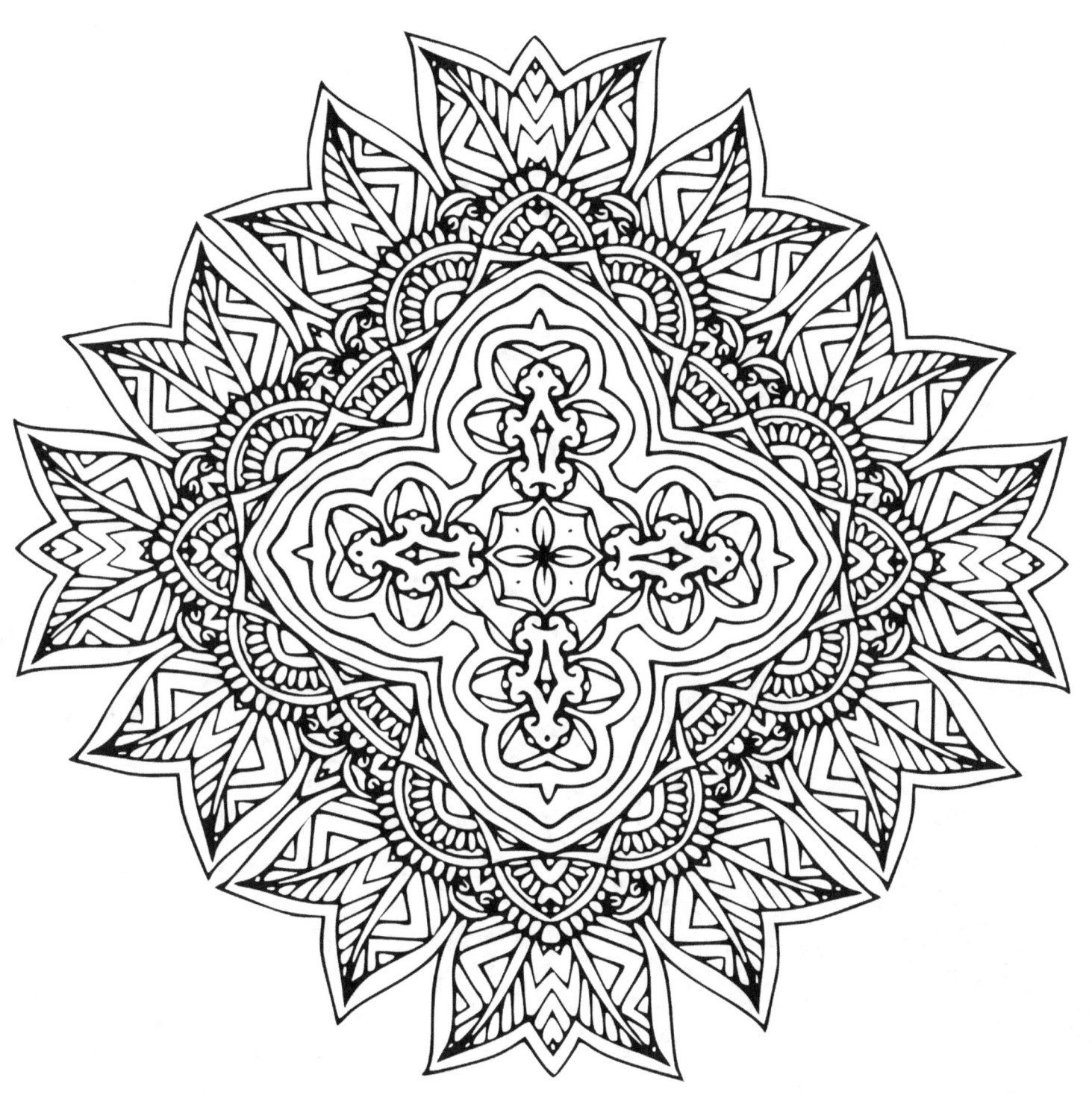

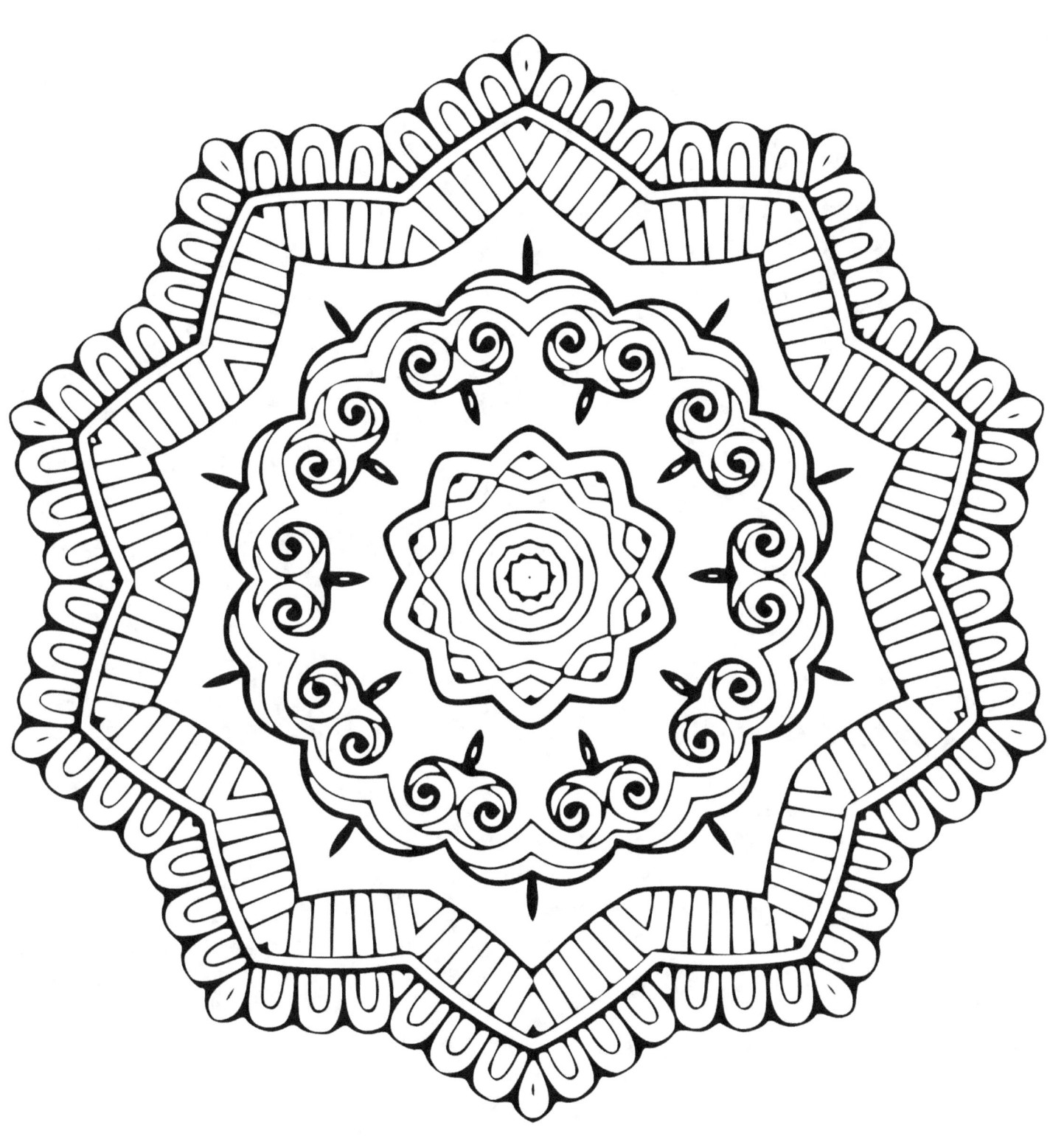

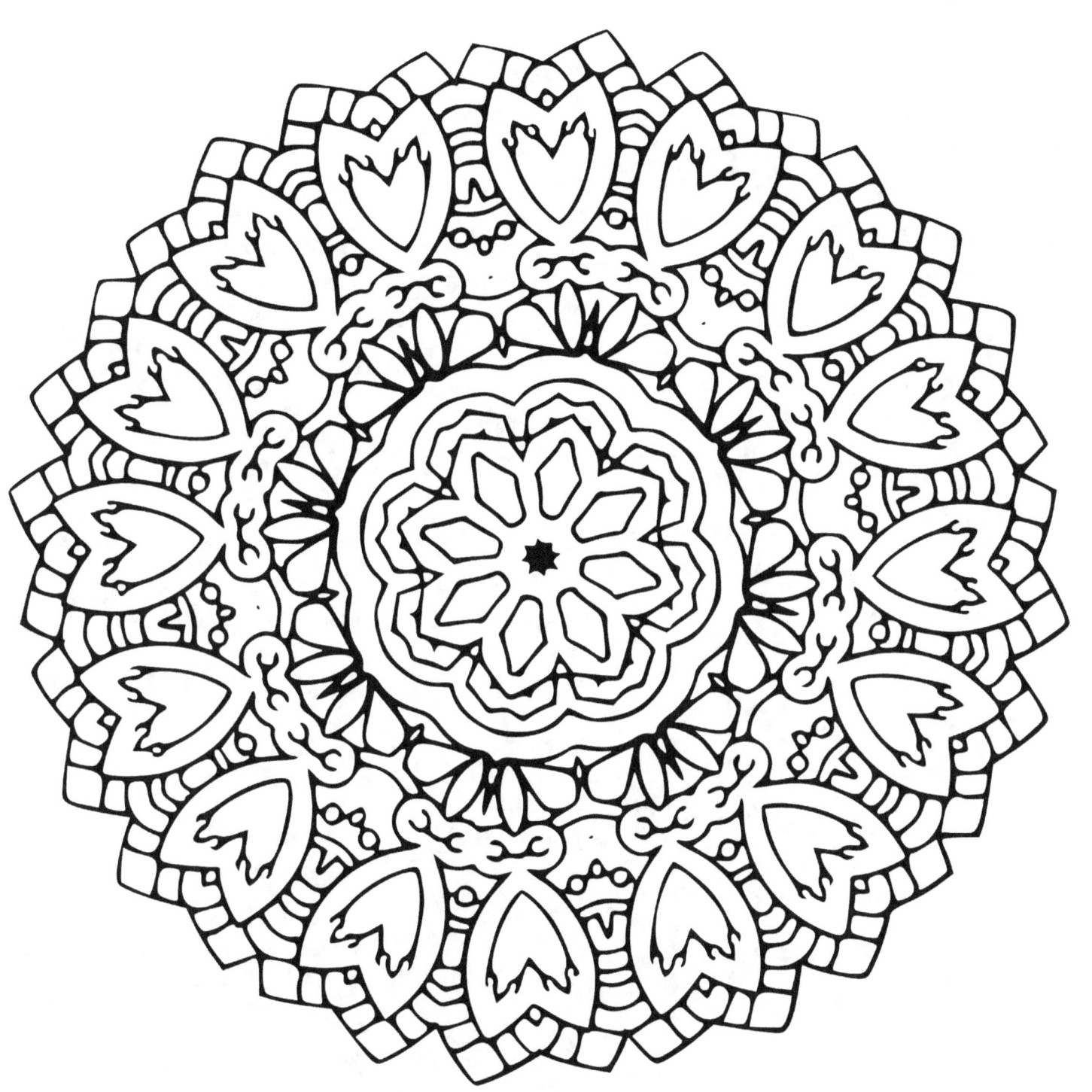

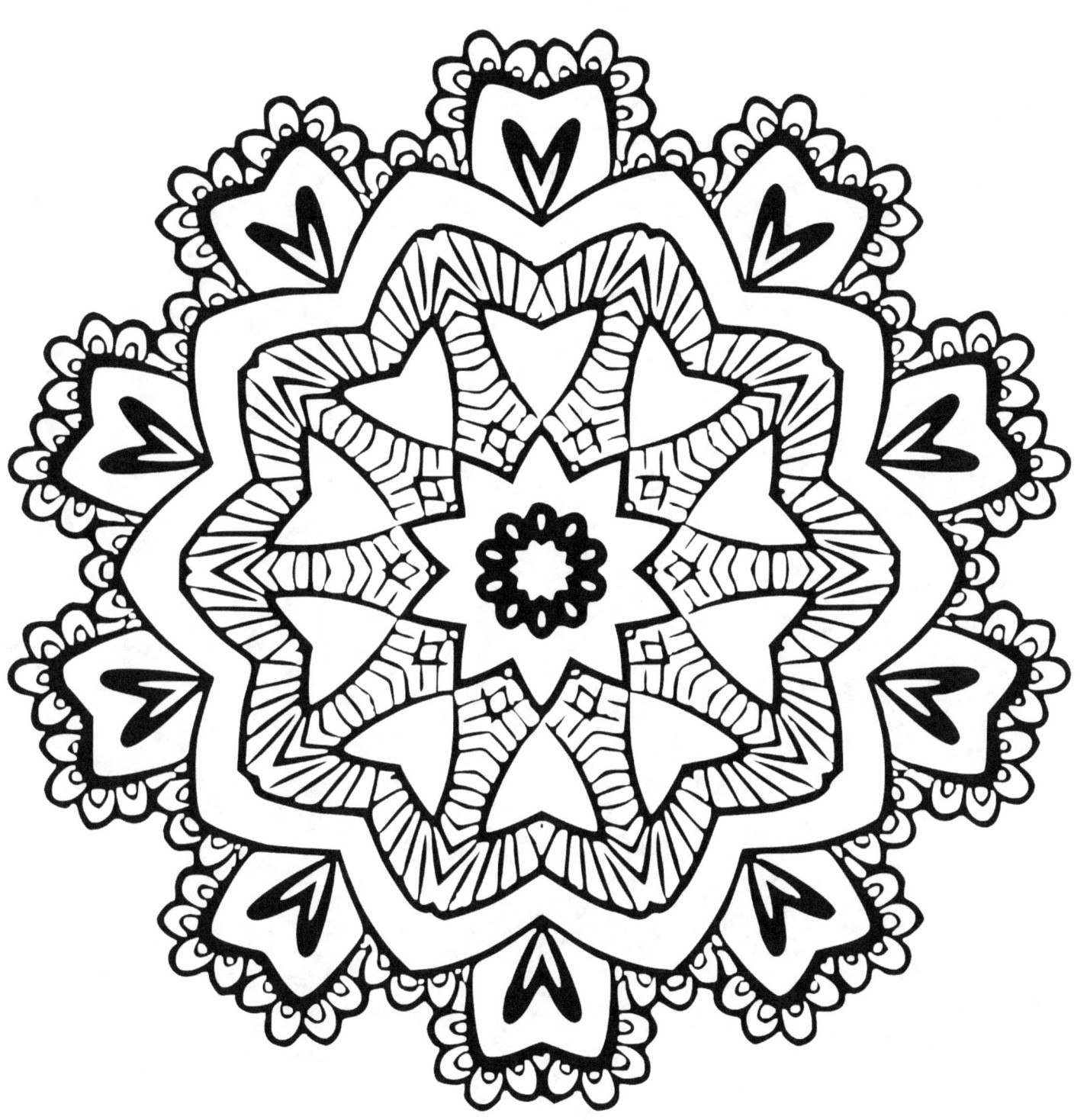

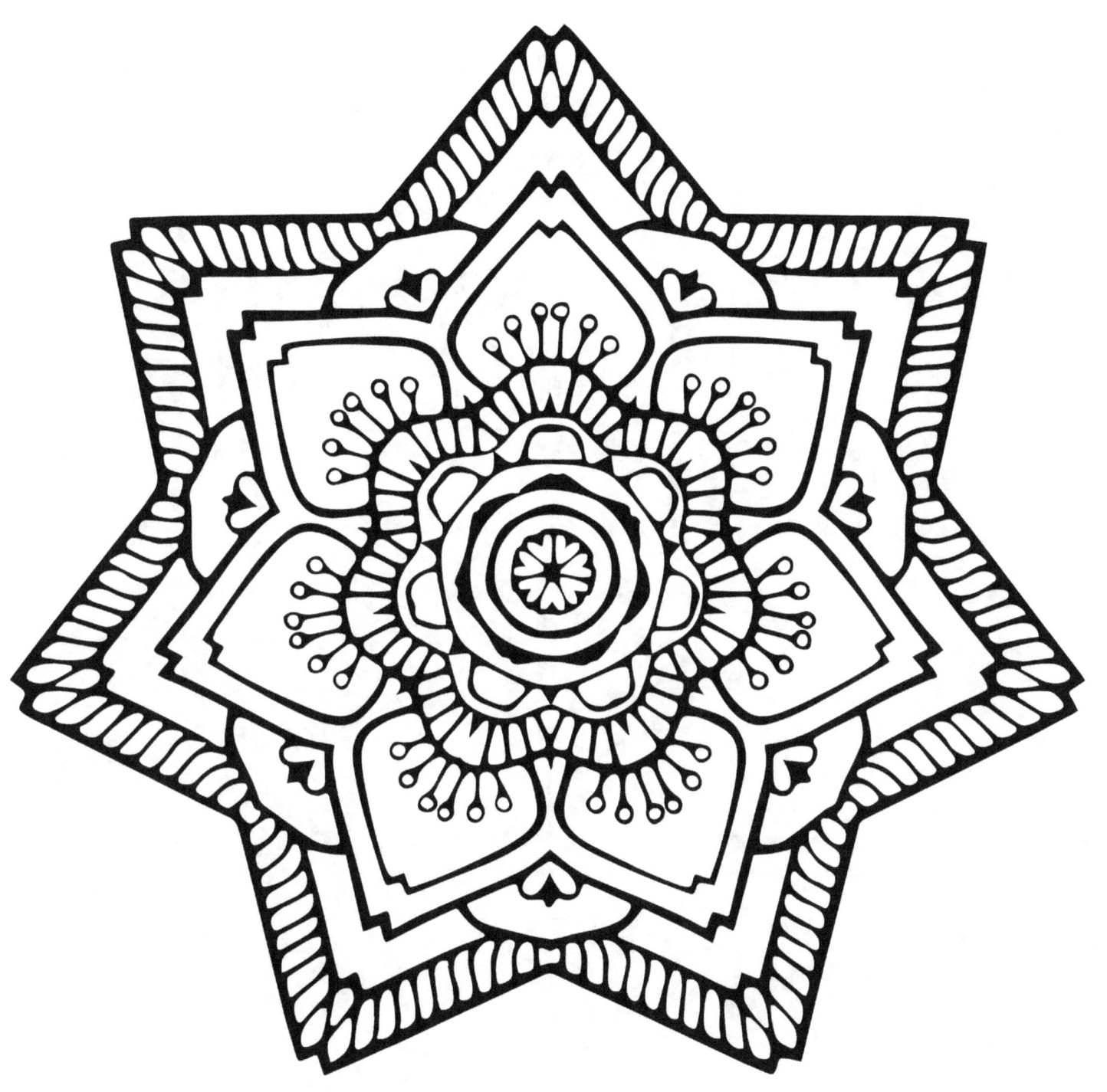

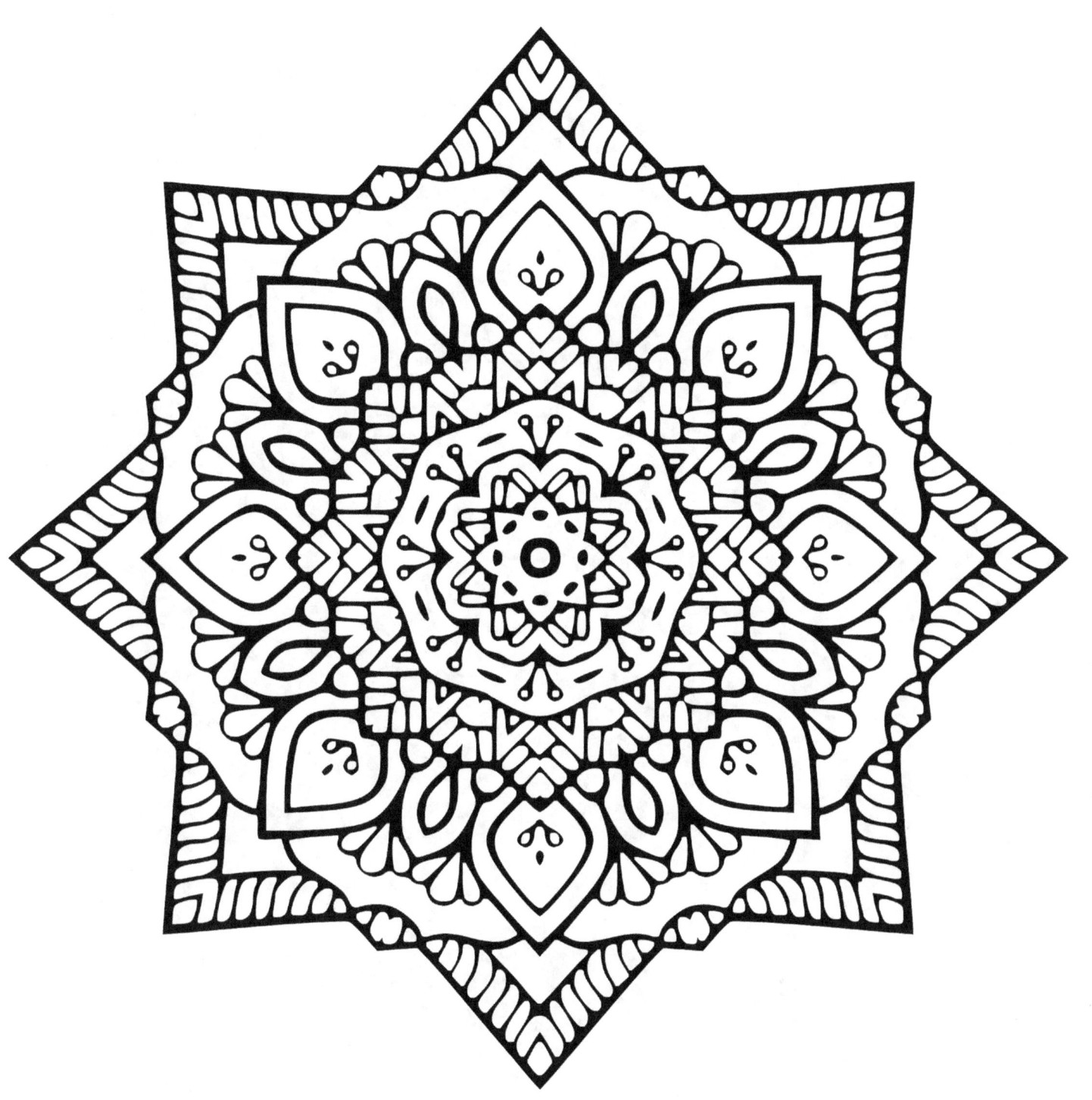

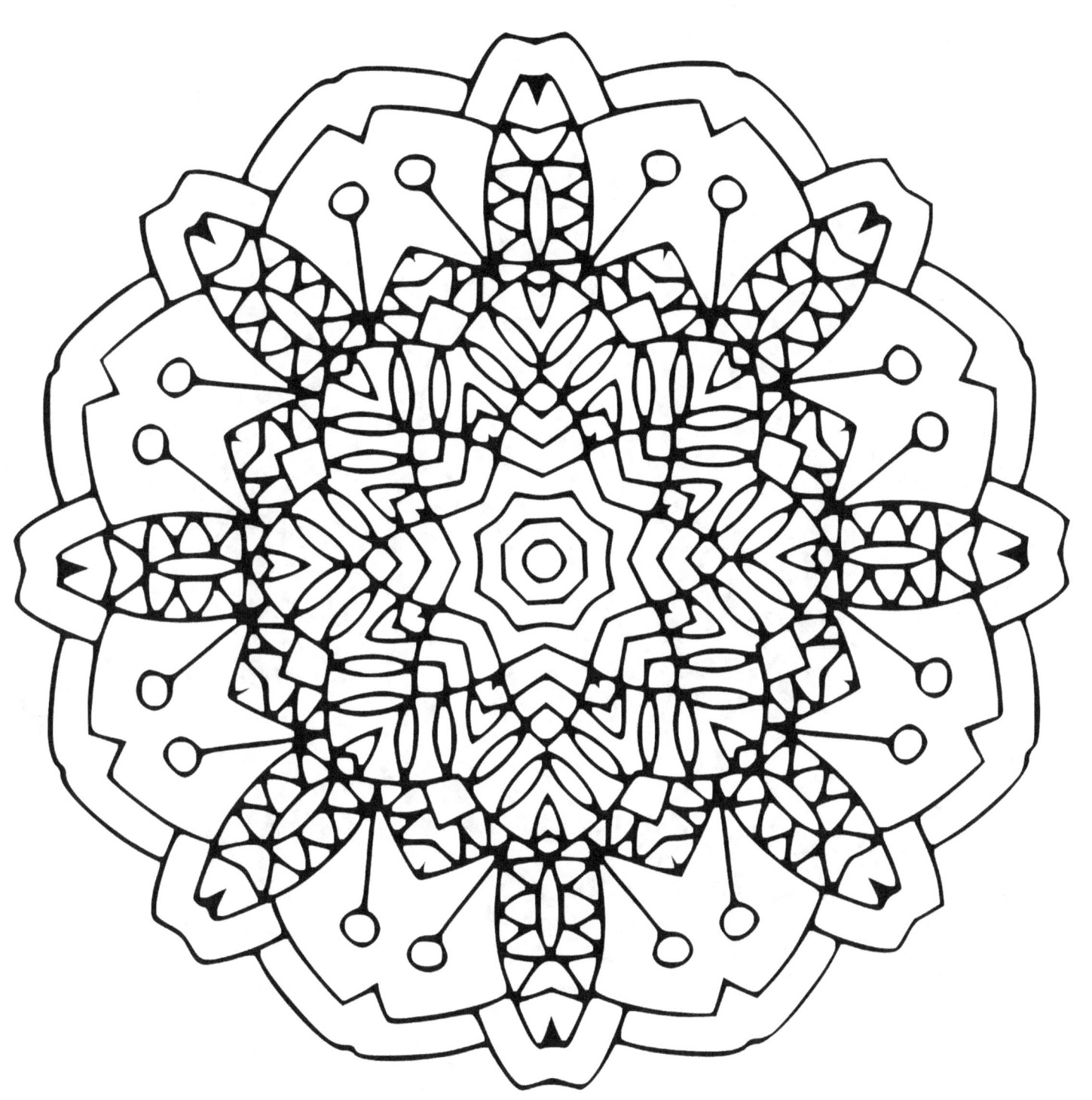

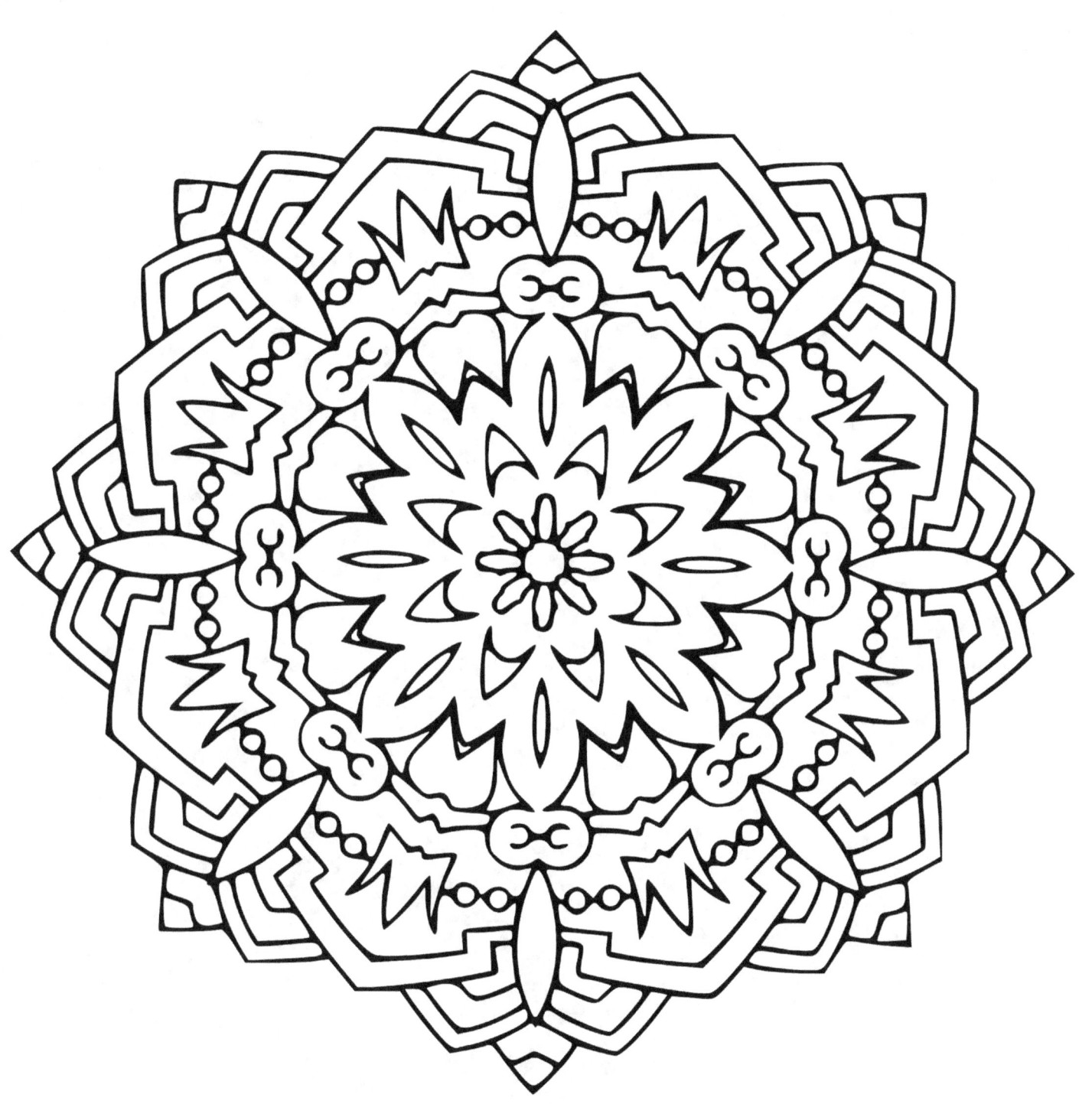

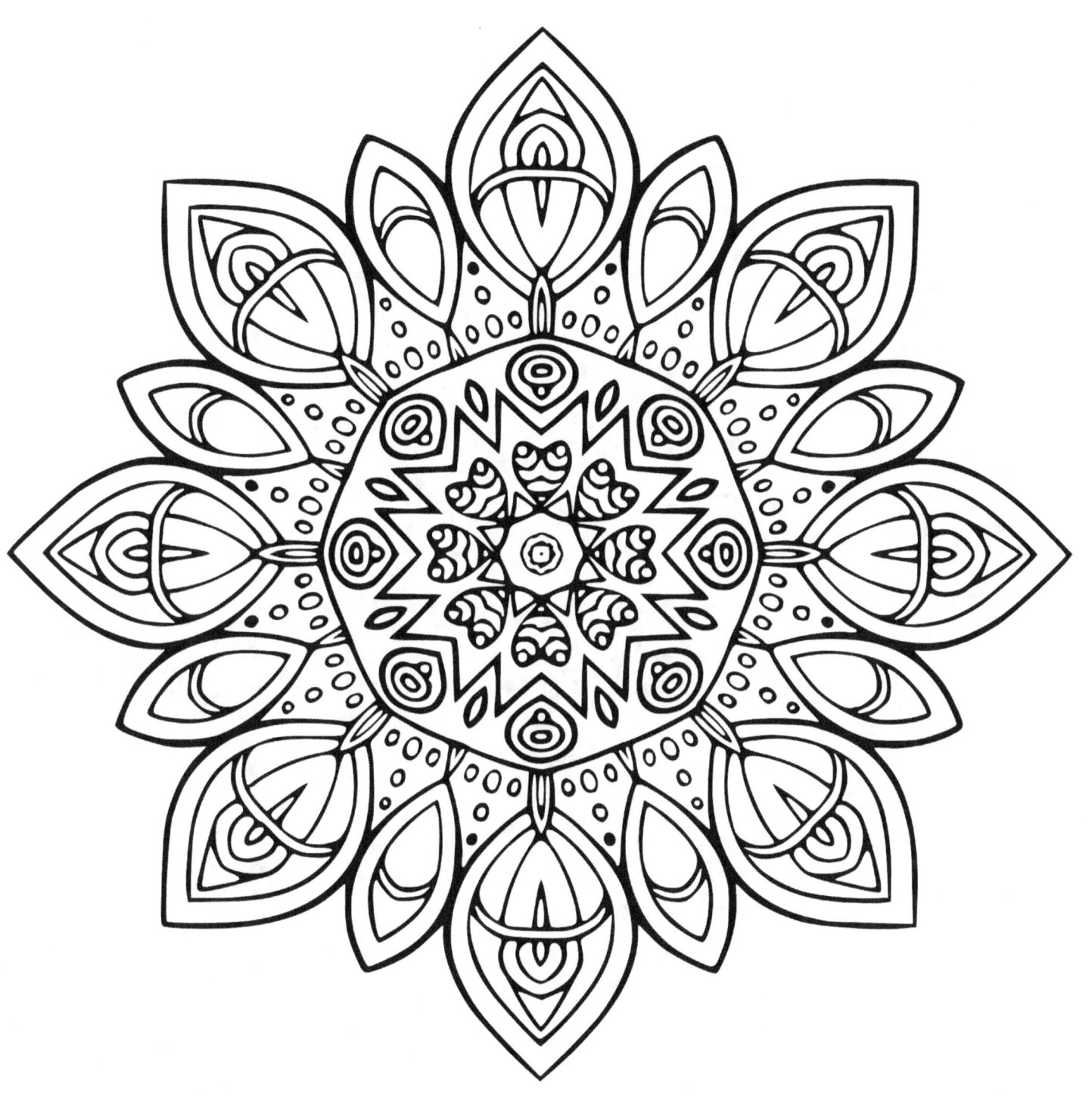

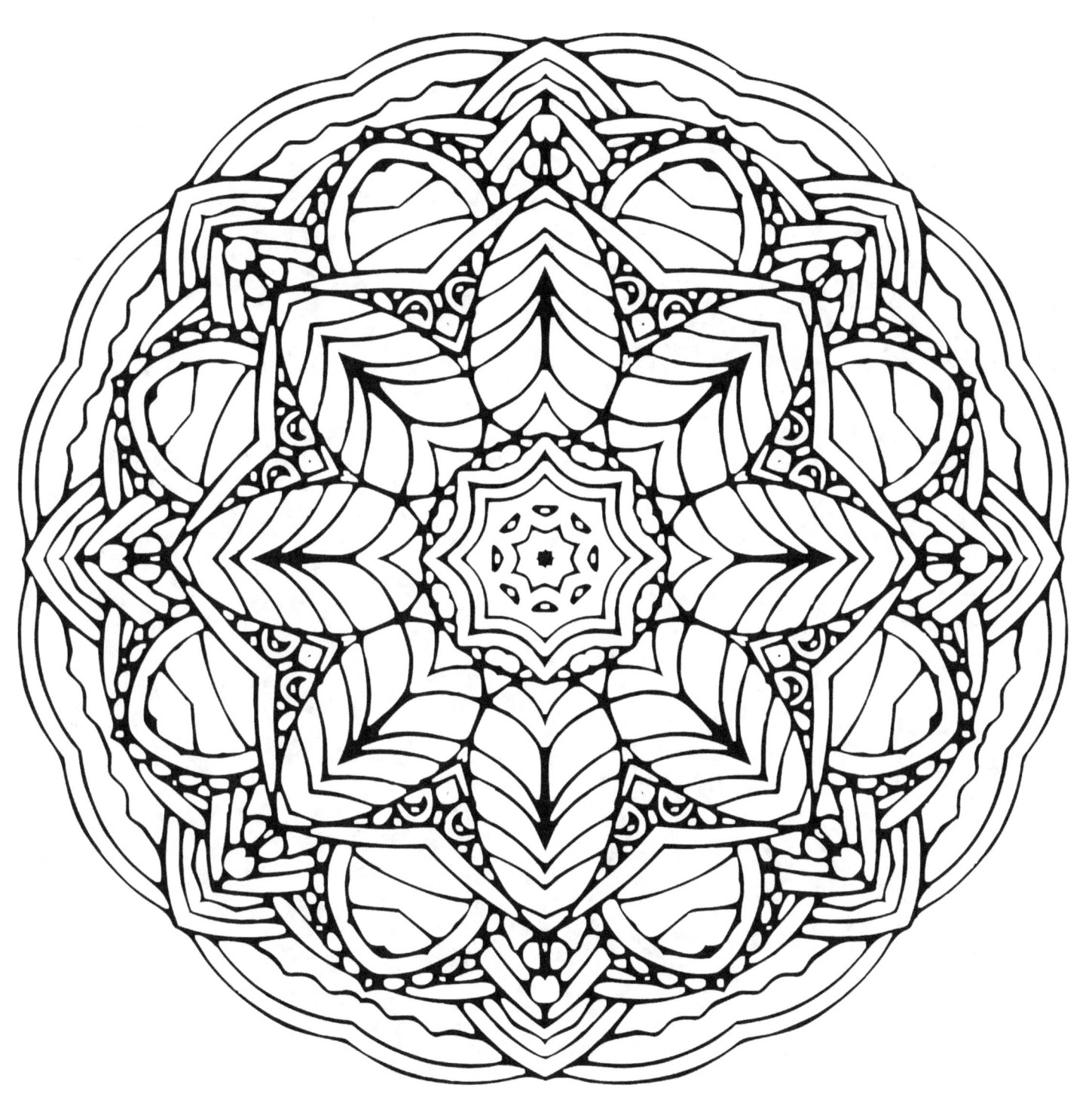

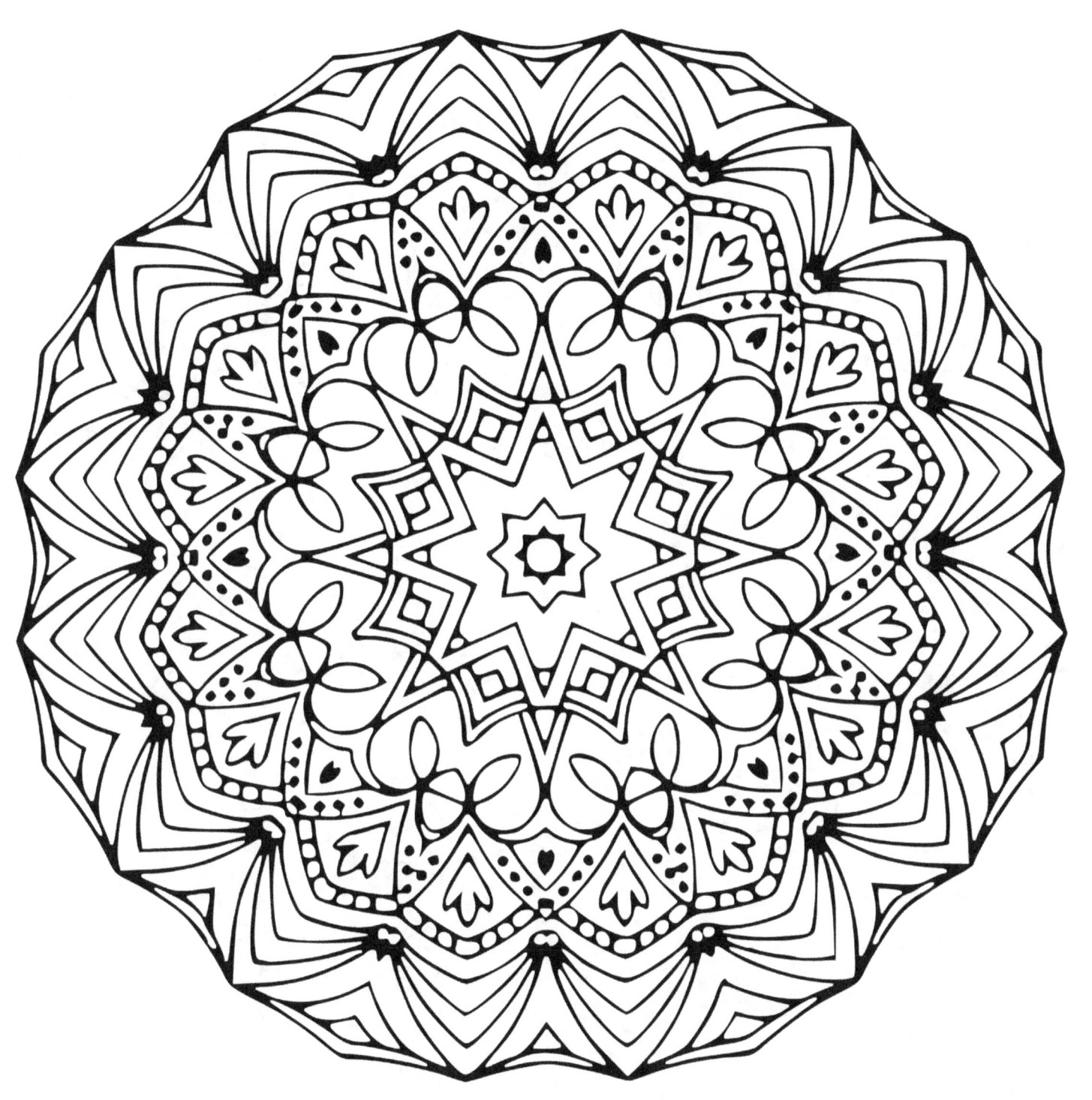

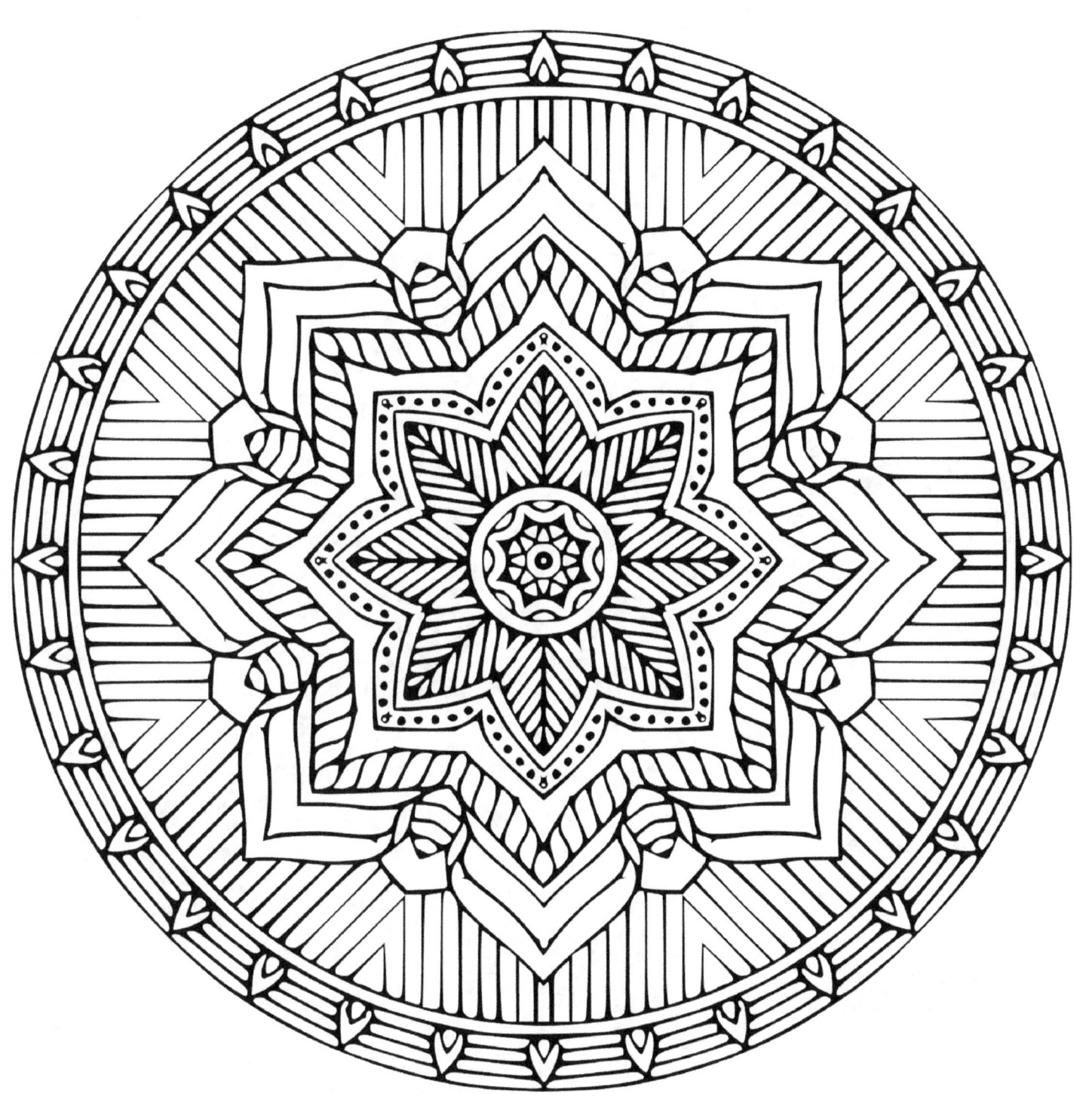

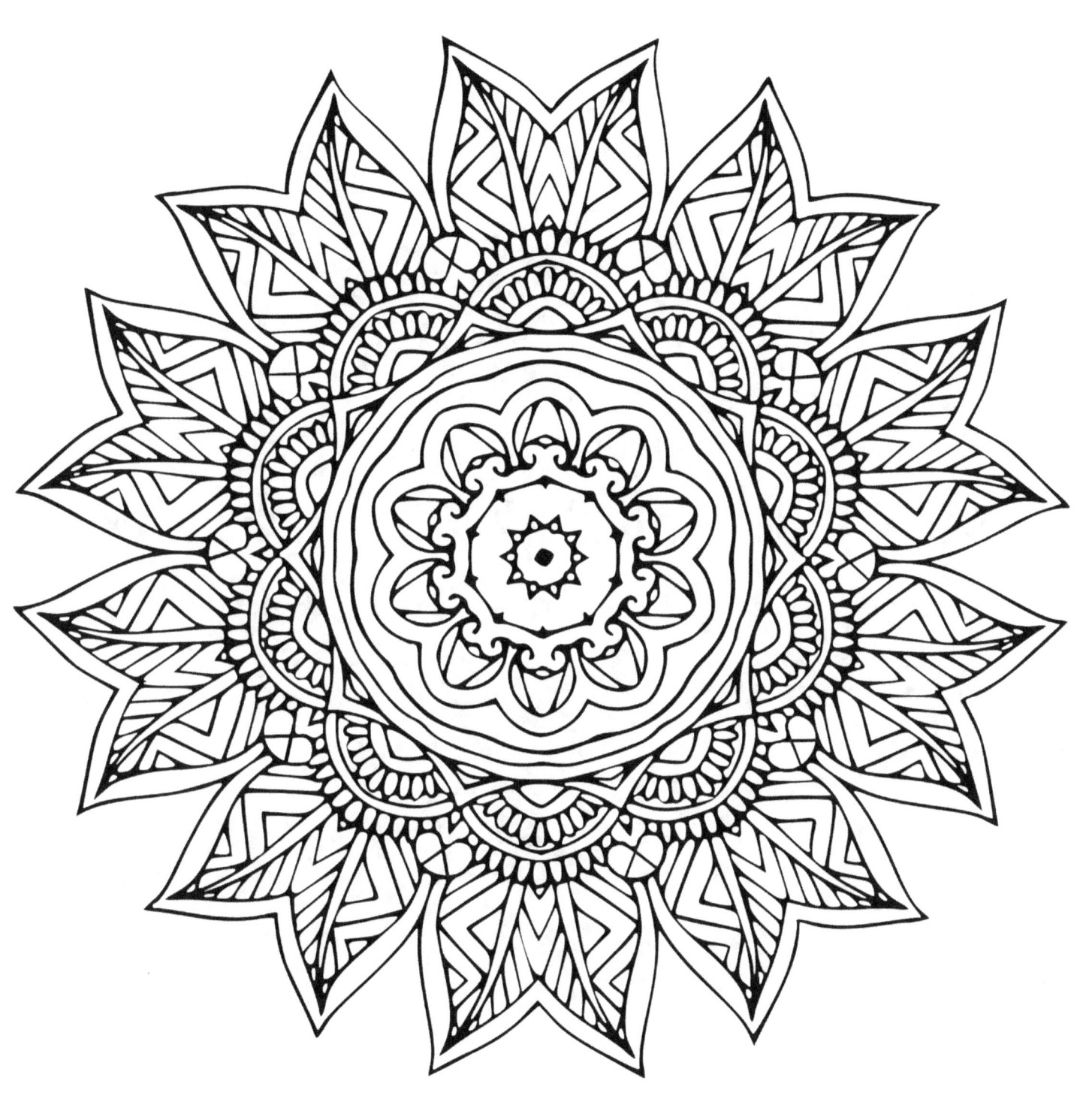

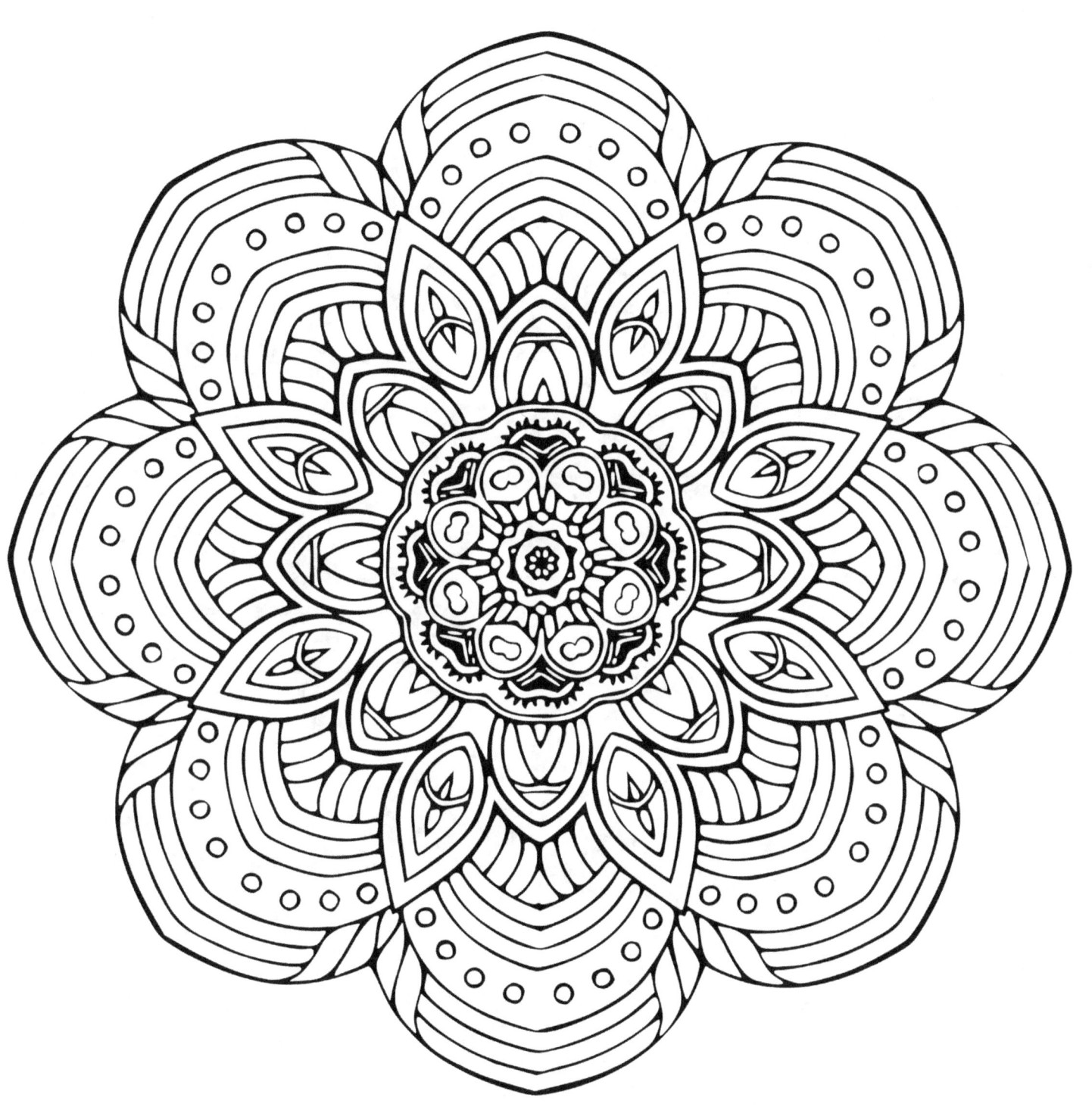

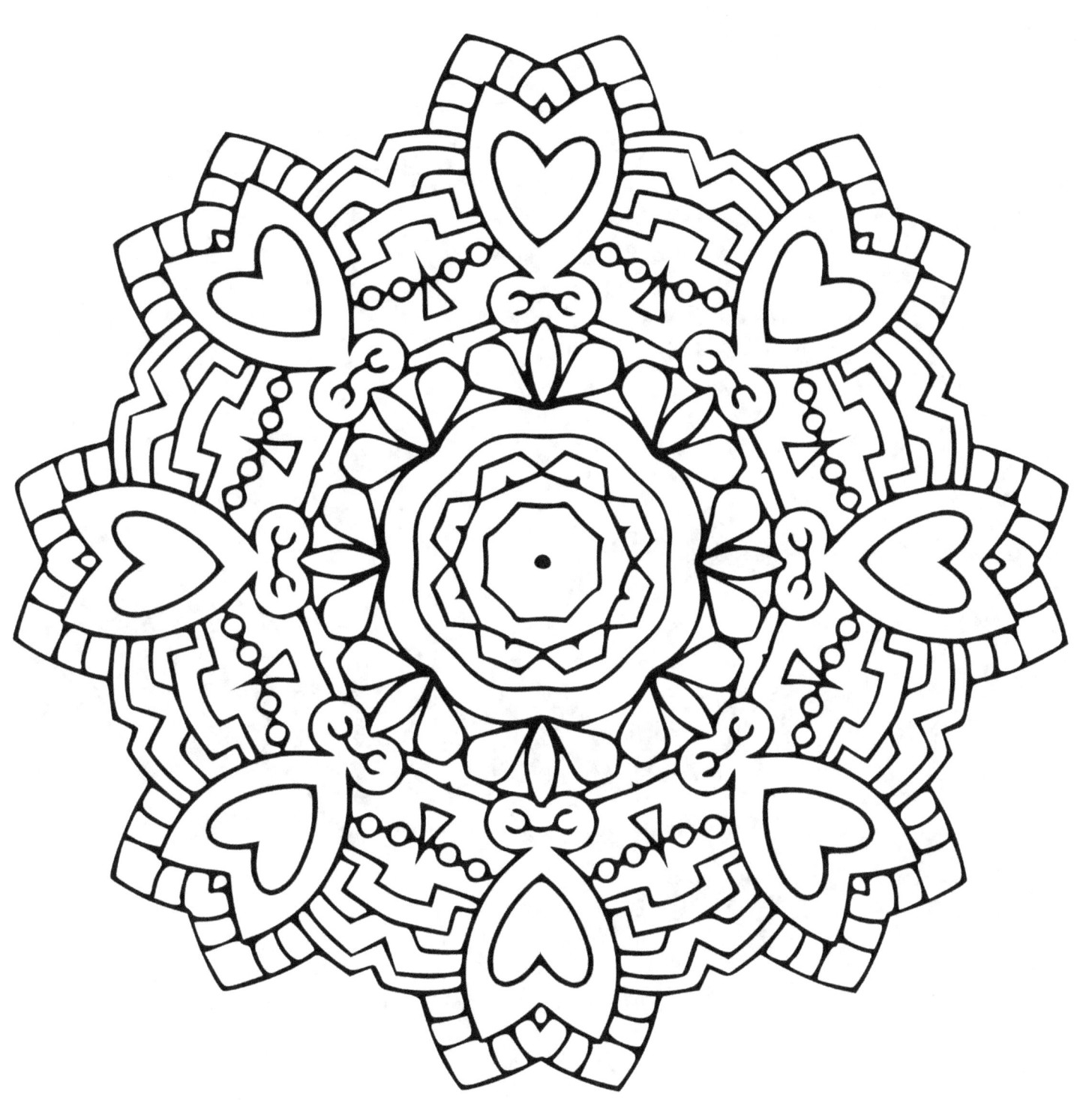

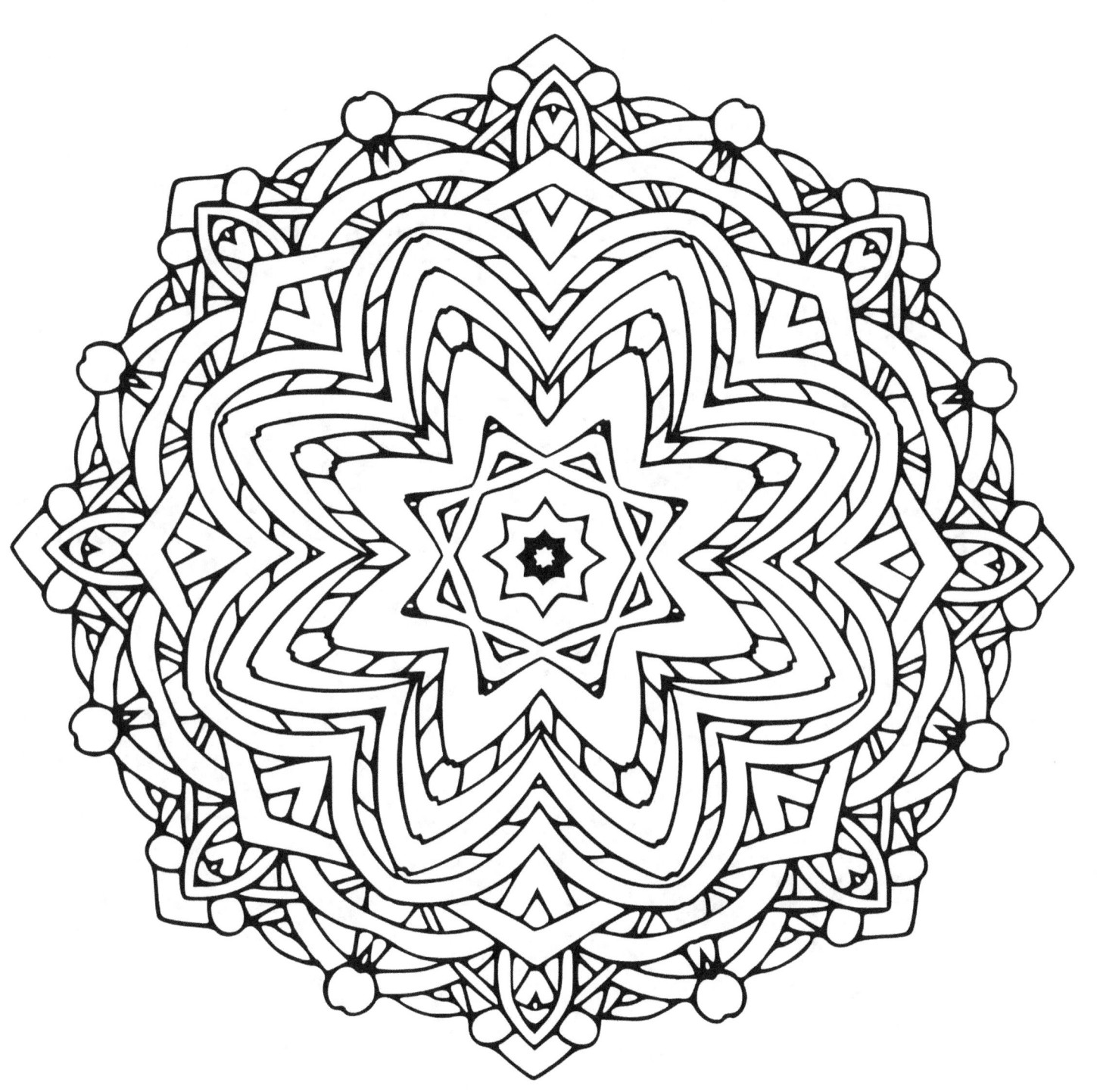

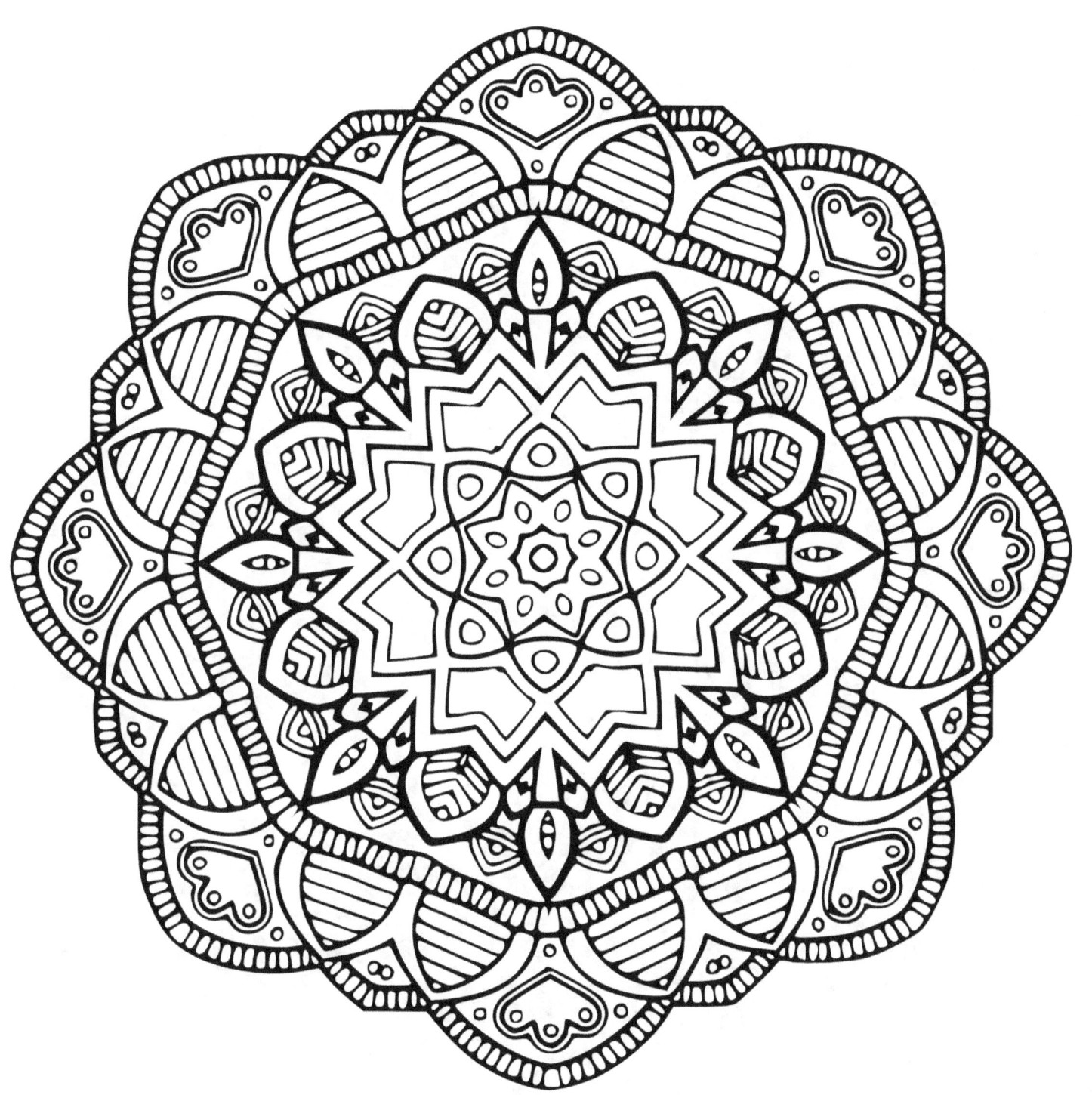

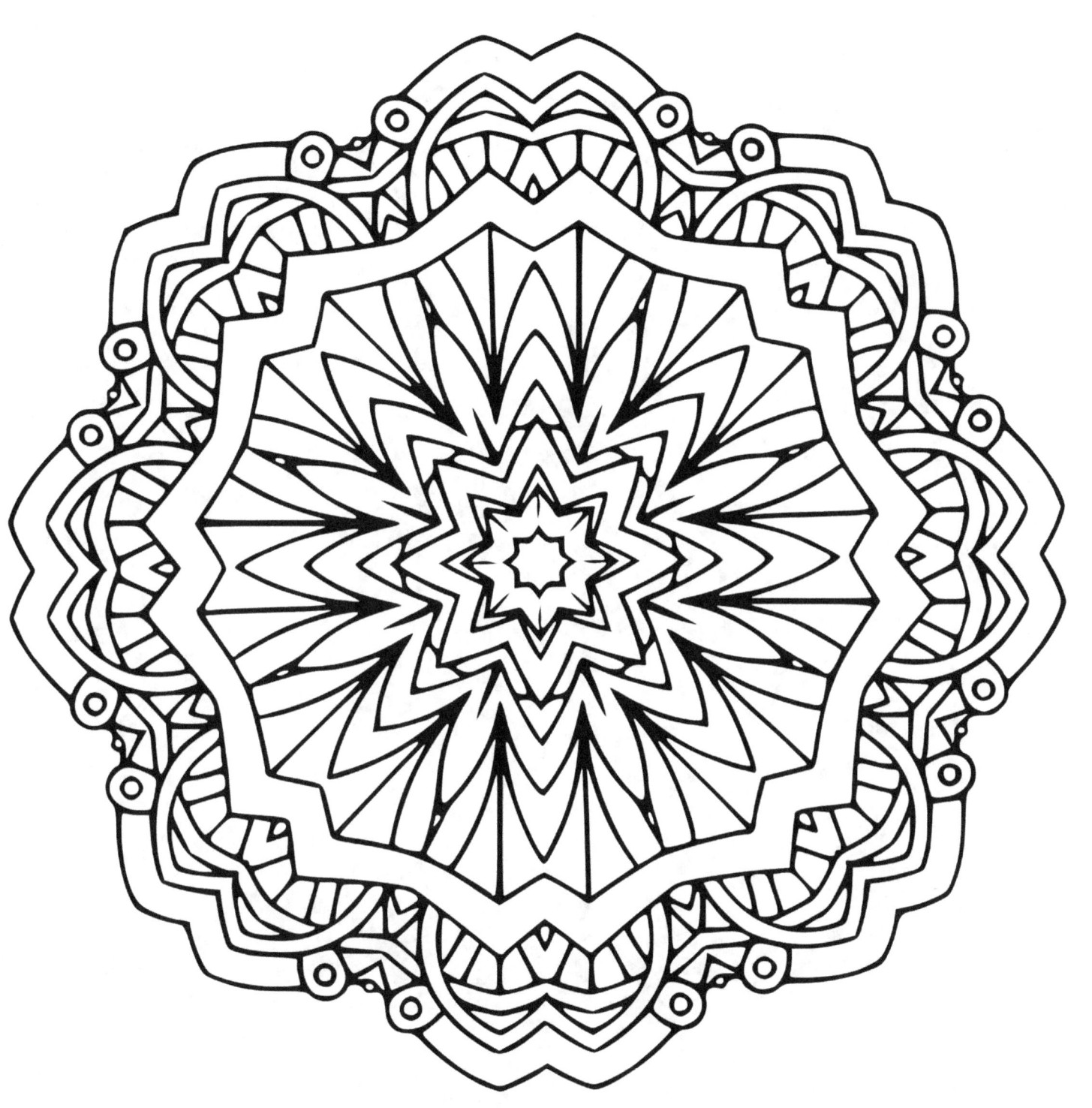

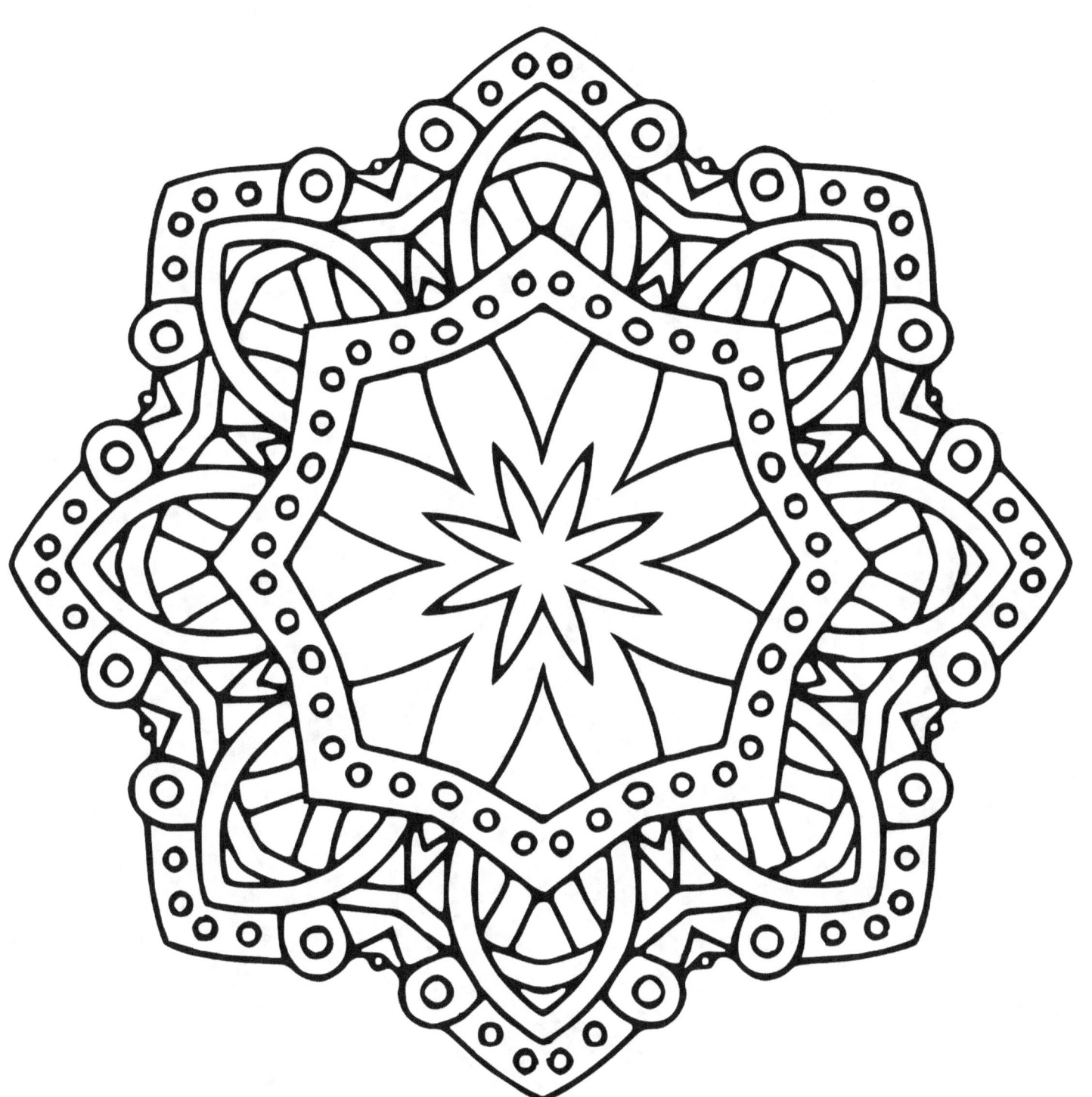

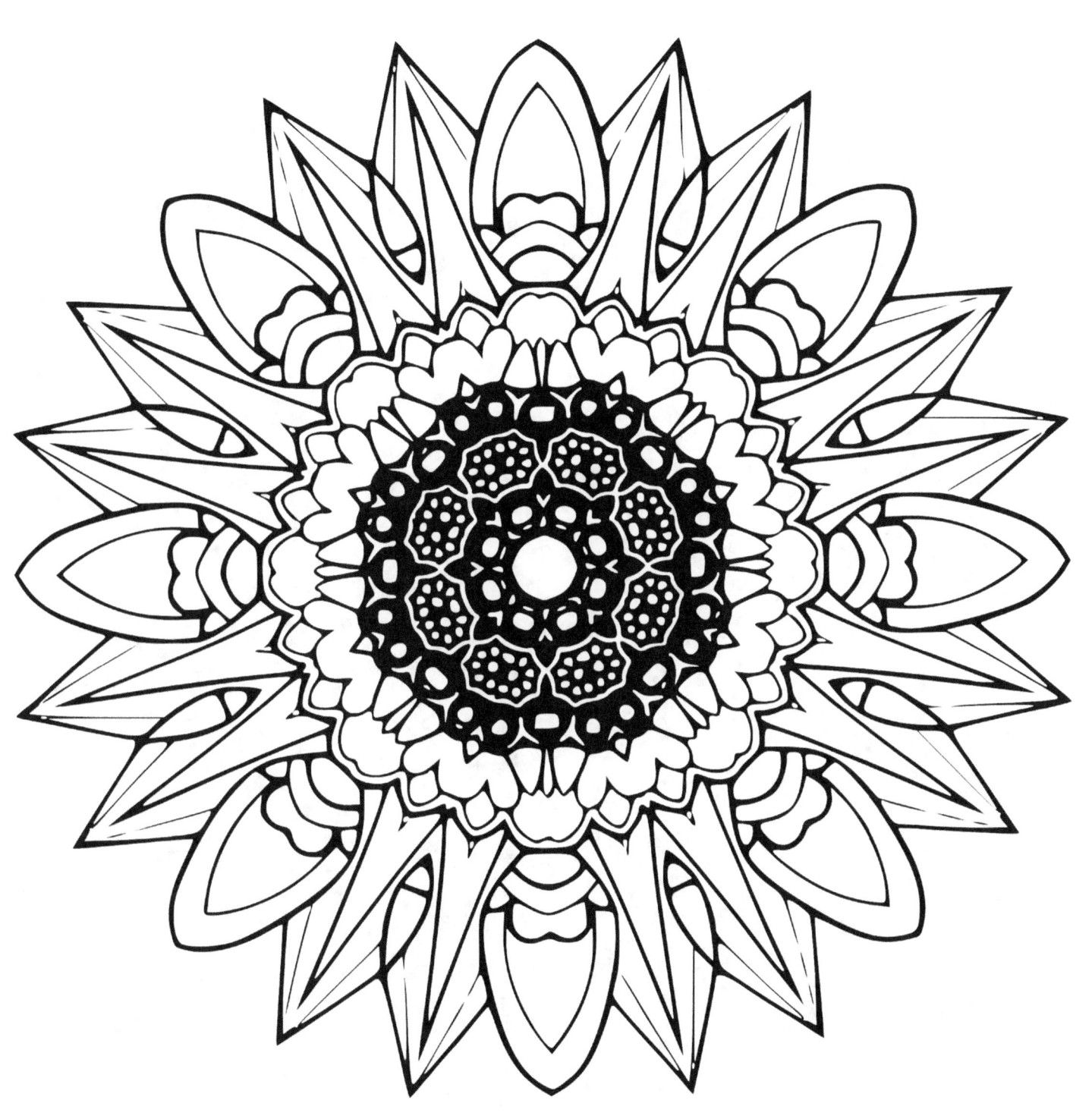

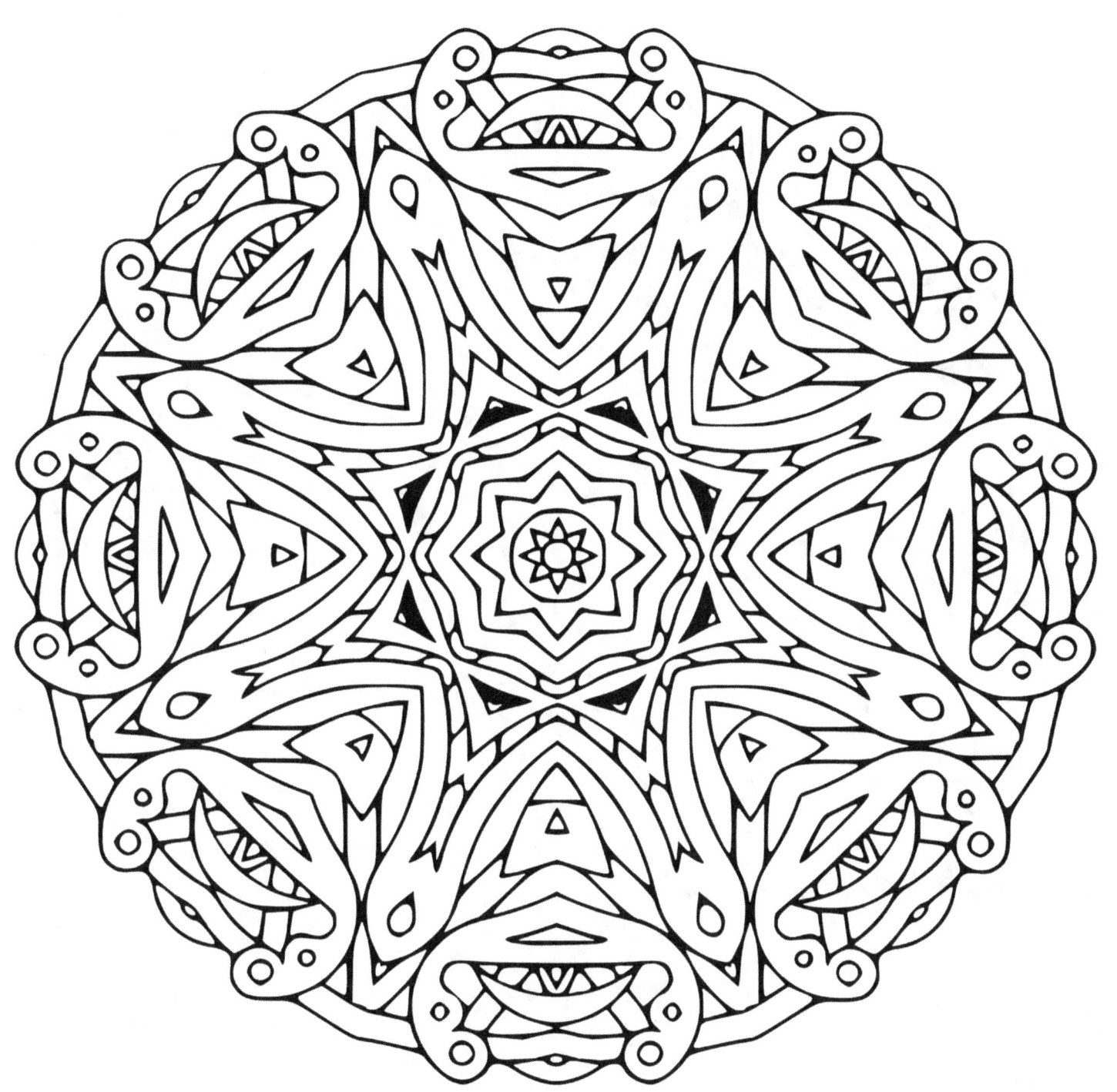

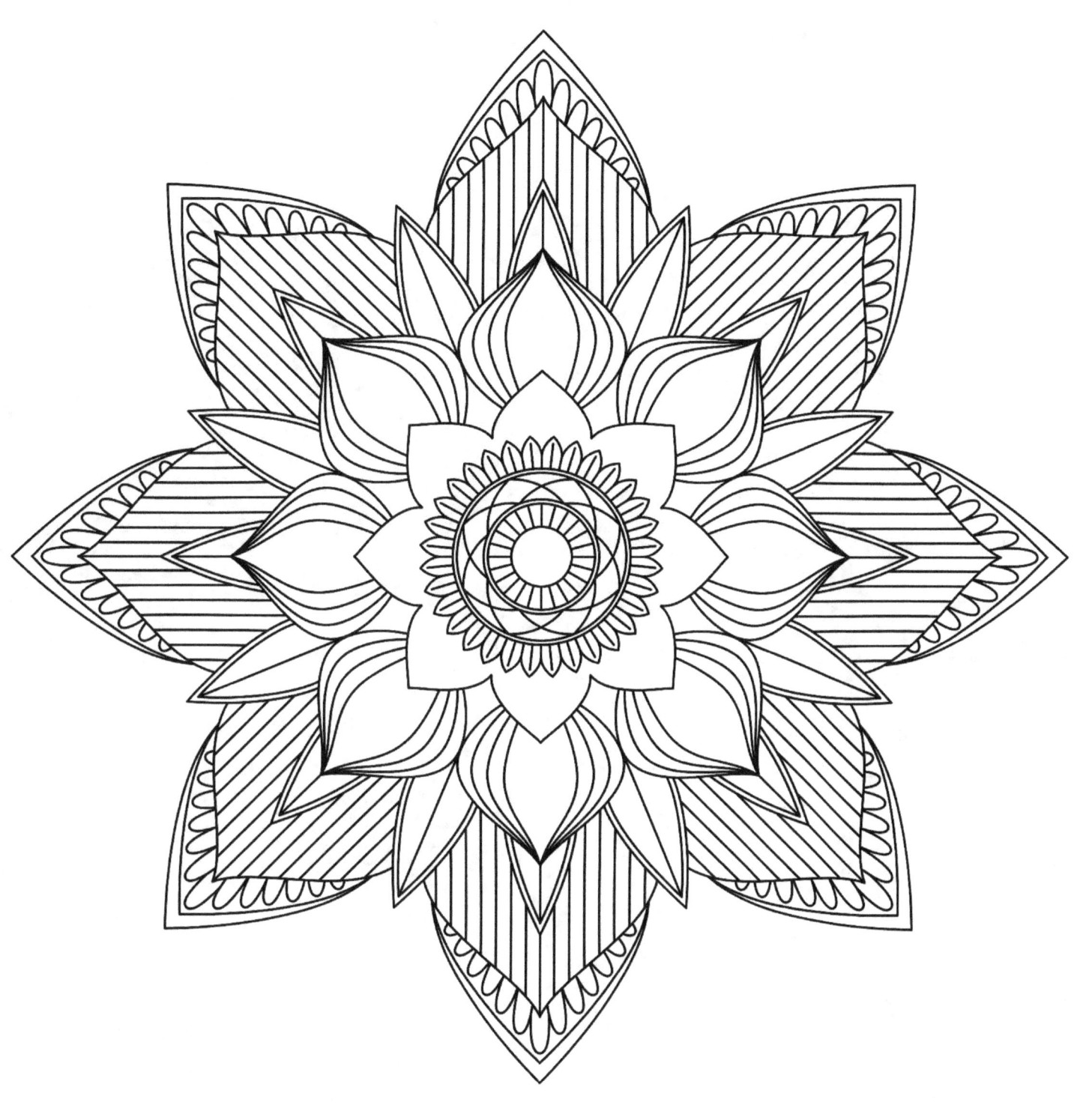

www.ingramcontent.com/pod-product-compliance
Lightning Source LLC
Chambersburg PA
CBHW081655220526
45466CB00009B/2760